A Keepsake

MAINE

Antelo Devereux Jr.

4880 Lower Valley Road • Atglen, PA 19310

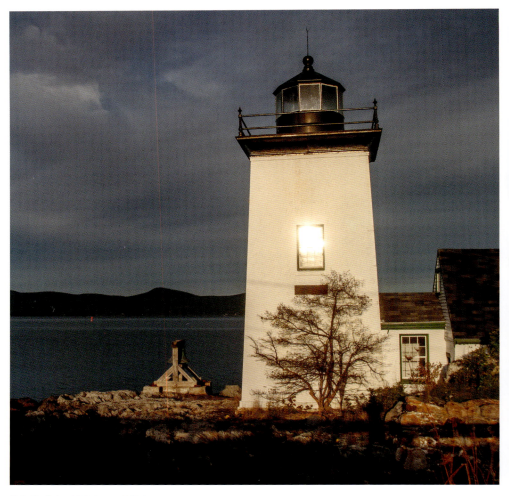
Grindle Point Lighthouse, Islesboro

INTRODUCTION
Maine—the Way Life Should Be

The Red Paint People and, later, the Wabanaki—or people of the dawn—were the first human inhabitants of the territory they called Wabanakigok. European contact with the coast was possibly by Norsemen and certainly by John Cabot in the late 1400s. A settlement headed by George Popham was attempted in 1607. It failed, and the settlers who remained sailed back to England in the first boat built in Maine, a pinnace named *Virginia* (a replica was launched in Bath in 2022). As the New World was colonized, Maine was fought over by the French, Native Americans, and English. The latter eventually took control of the land as part of Massachusetts until it become the country's twenty-third state in 1820.

Maine flourished throughout most of the nineteenth century. Lumber, ice, granite, lime, and textiles, not to mention fishing, propelled its economy. Mills were constructed along the Kennebec, Penobscot, Androscoggin, and other rivers. Ships were built along the coast in such seaports as Belfast, Rockland, Damariscotta, and Bath. Towns both inland and along the coast grew. Large houses remain today as evidence of the great wealth of the times, as do mills and dams along the major rivers. Shipping also was a major industry, and many captains' and owners' houses still remain. Both standard- and narrow-gauge railroads were laid down to penetrate the vast areas inland and gain access to natural resources. To the very north, Aroostook County became known for its agriculture, most notably for potato farms.

As the US expanded and the center of economic gravity moved south and west, Maine's economy slowly declined. Today, paper and lumber mills are quiet and shipping is barely evident, but the remains of former activities are visible. Now tourism, hunting, fishing, and snowmobiling have taken over, both along the coasts and in various spots inland. More recently, Maine has seen a surge of people seeking permanent homes.

These ninety images capture bits of what remains from the old days and what makes the state a wonderful place to visit, travel, and live in today. They illustrate why Maine is "the way life should be."

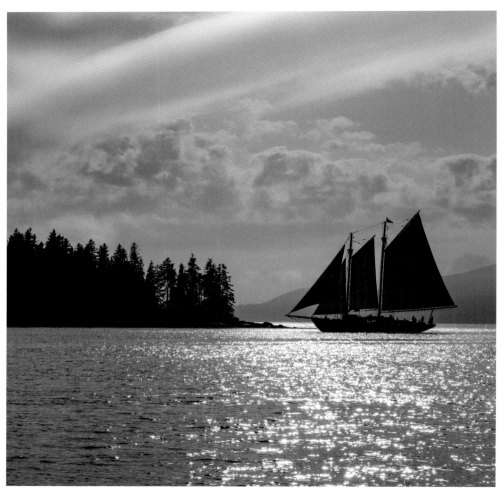

Penobscot Bay

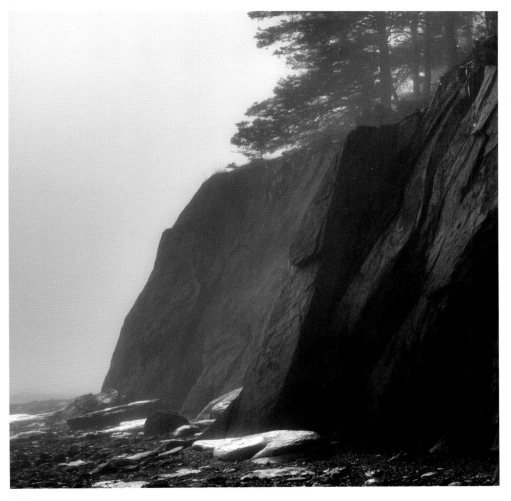

Islesboro

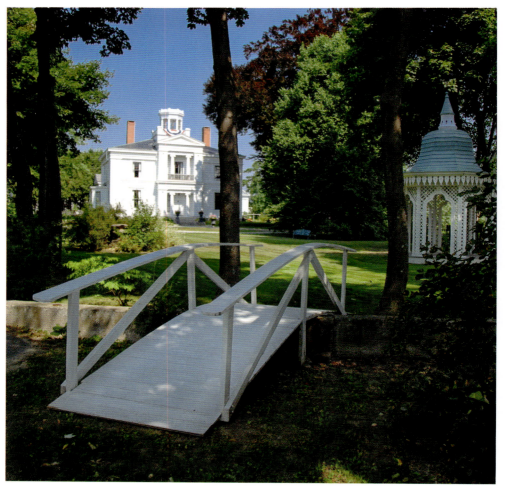

Belfast

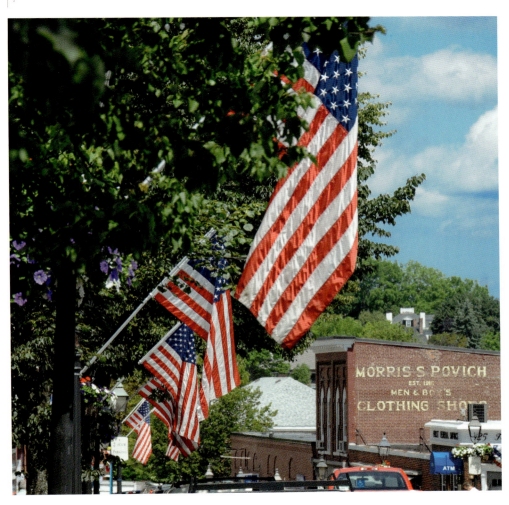

Belfast

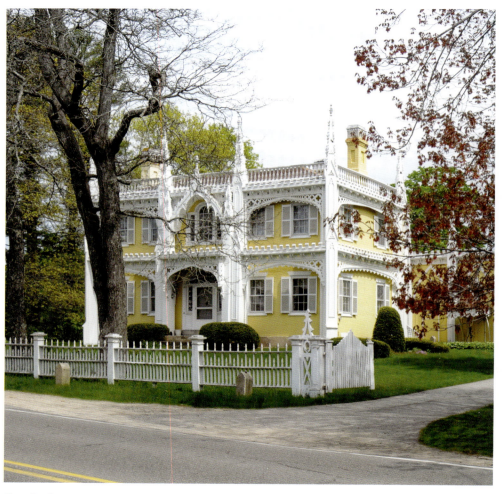

Kennebunk

Freedom

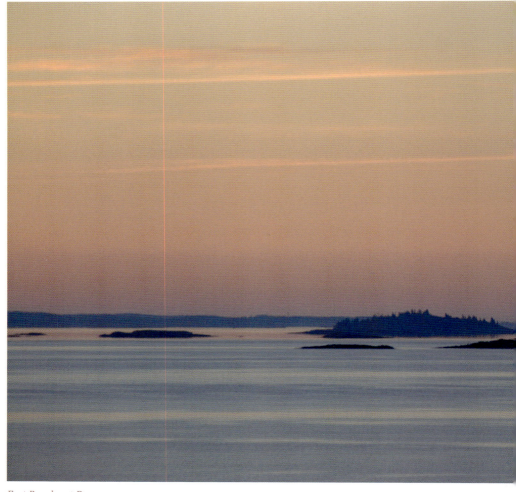
East Penobscot Bay

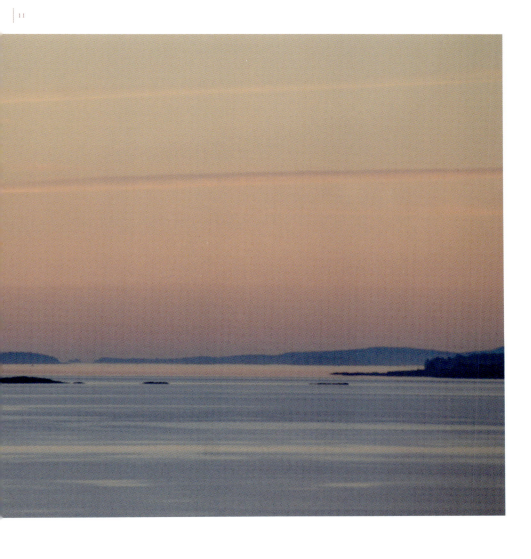

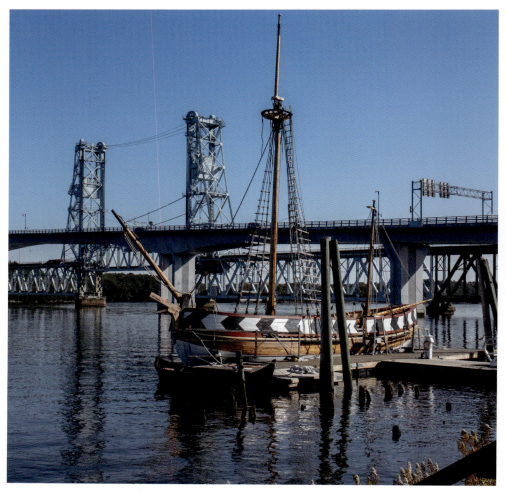

Pinnace Virginia, *Bath*

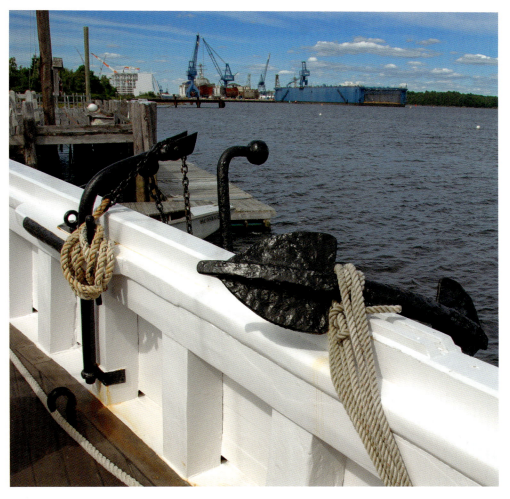

Bath

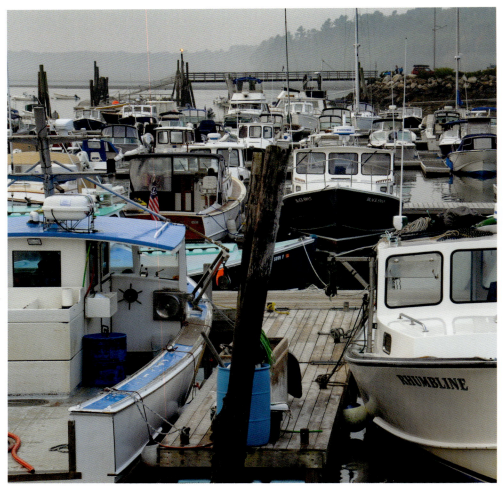

South Freeport

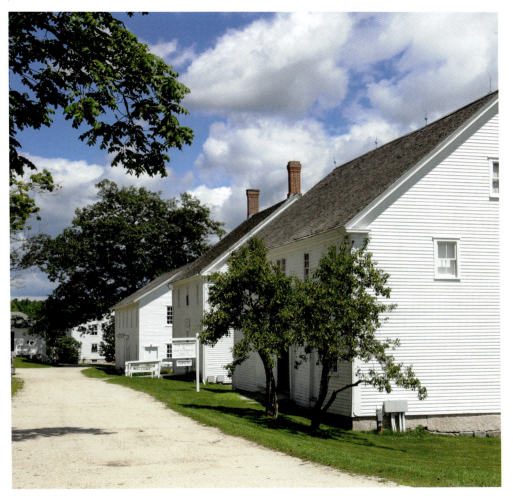
Shaker Village, Sabbathday Lake

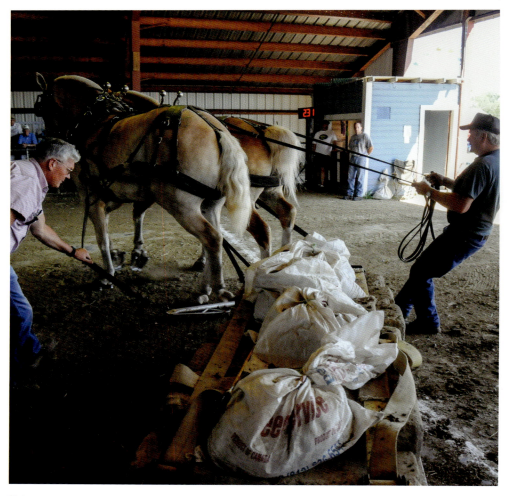
Union

Freeport

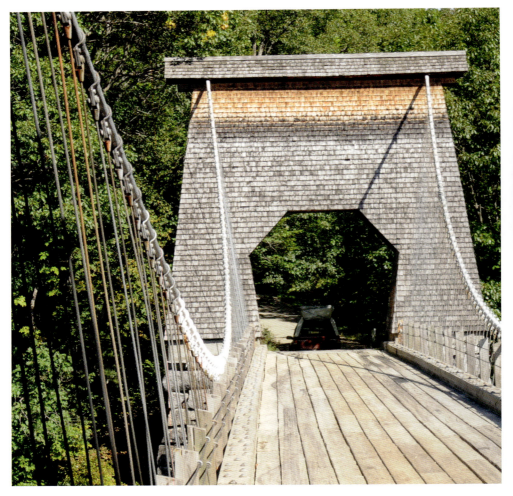

New Portland

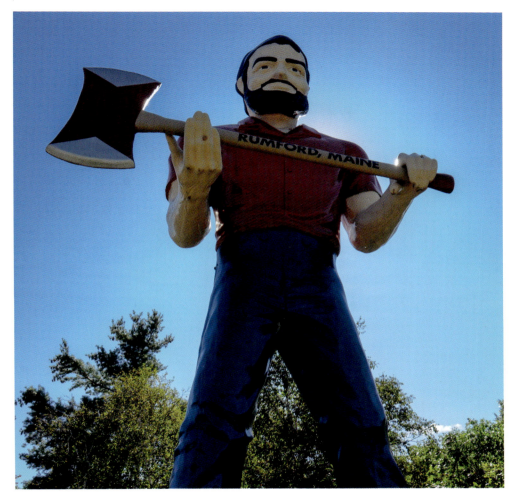

Rumford

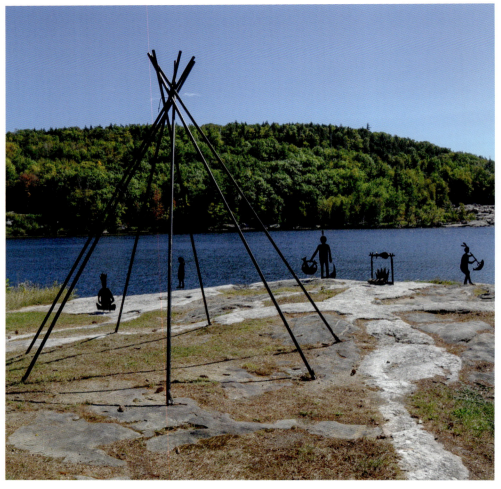

Rumford

Rangeley

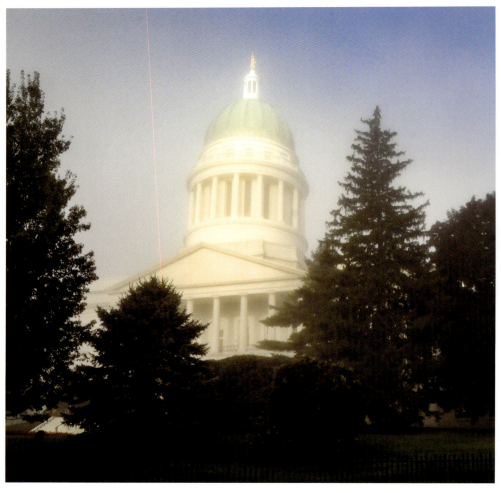

Bangor

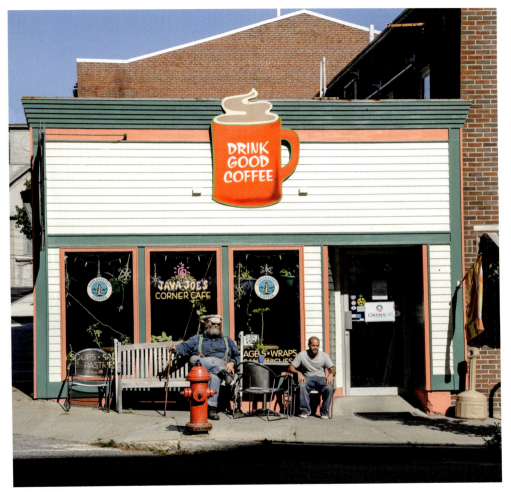

Farmington

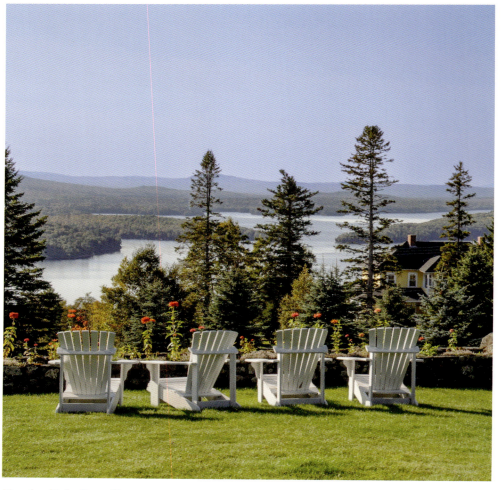

Moosehead Lake, Greenville

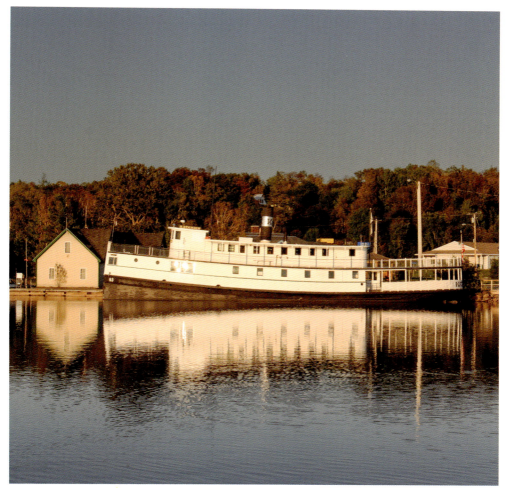

Moosehead Lake, Greenville

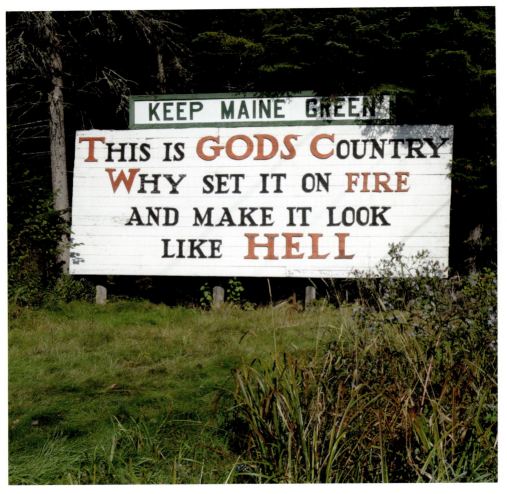

Moosehead Lake, Greenville

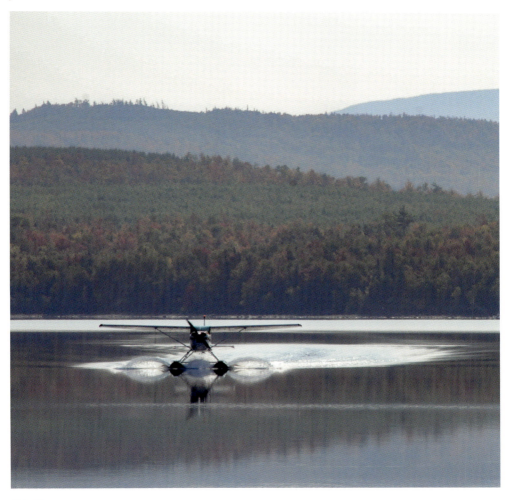

Kokadjo

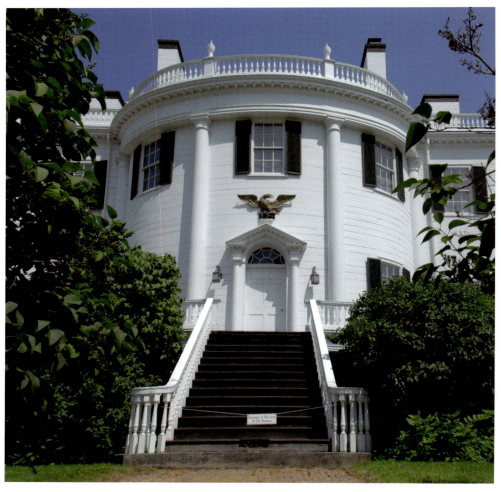

Knox Mansion, Thomaston

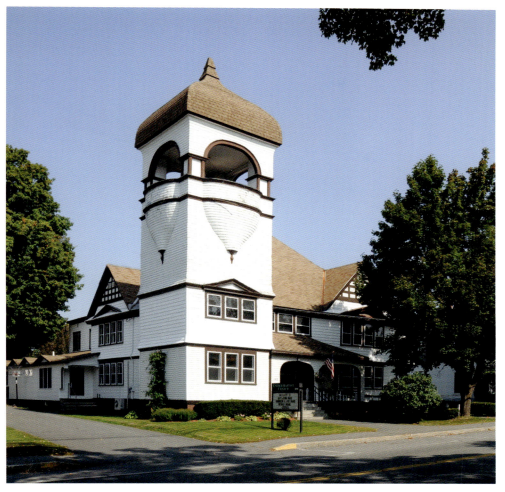

Dover-Foxcroft

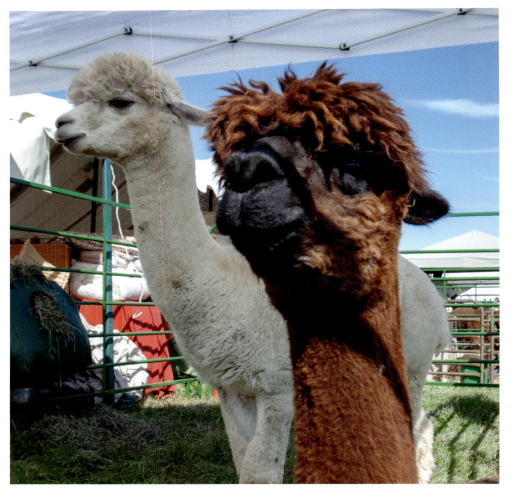

Alpacas, Common Ground Fair, Unity

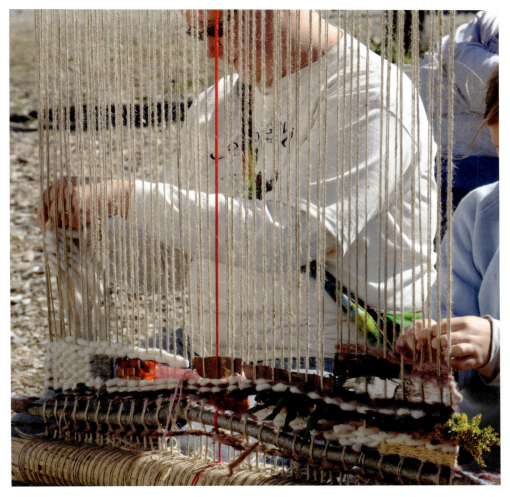

Common Ground Fair, Unity

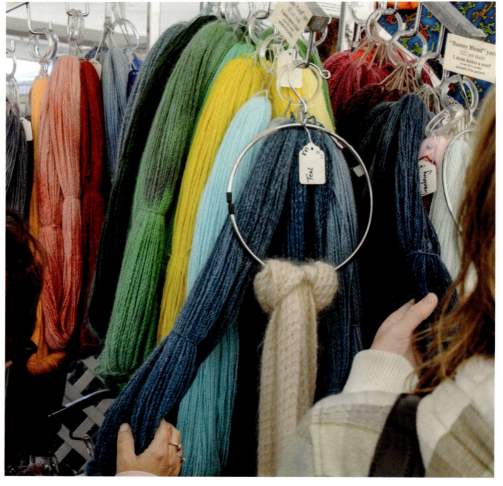

Fair, Camden

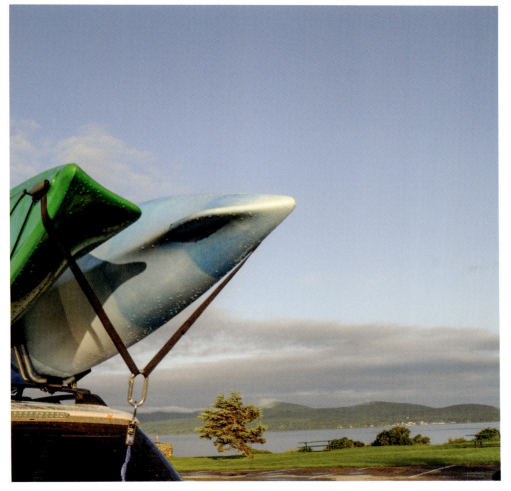
Kayaks

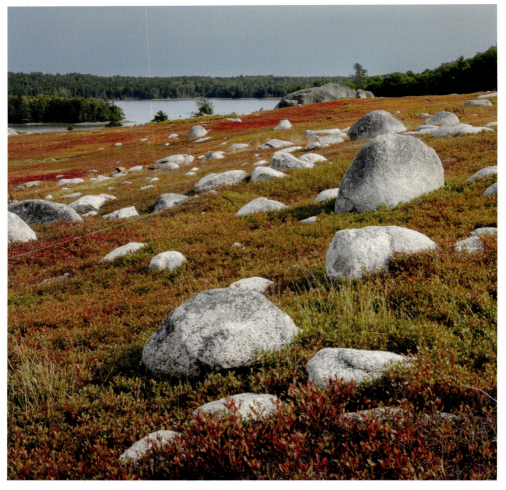

Blueberry field

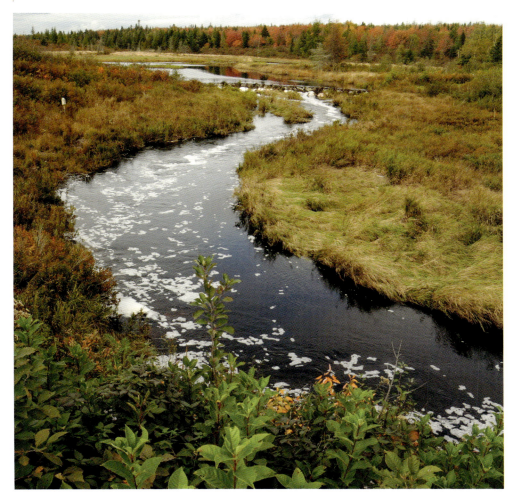

Winter Harbor

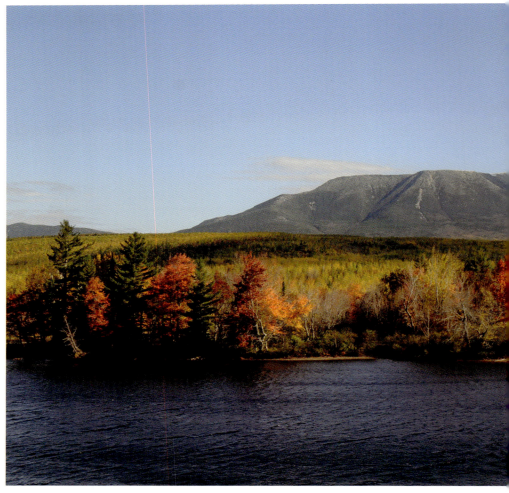

Mount Katahdin, Millinocket

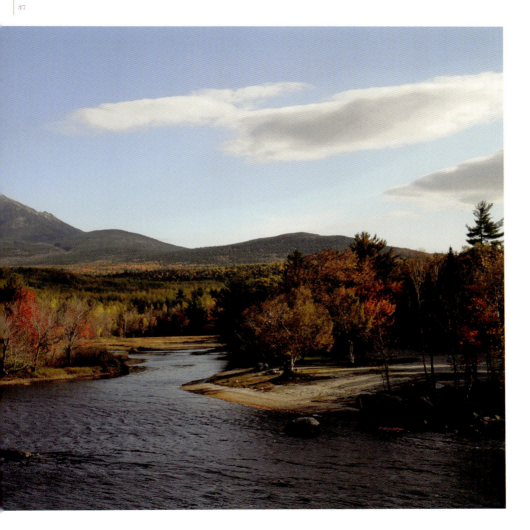

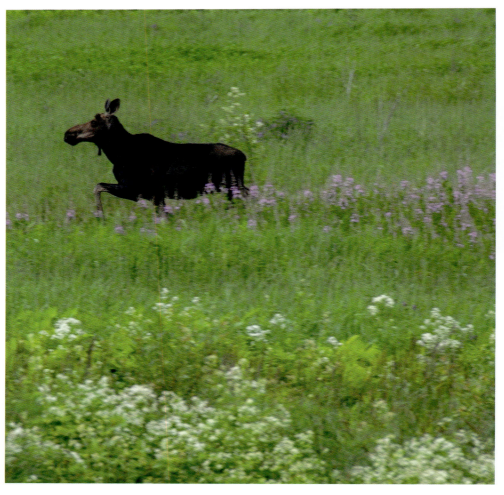

Moose

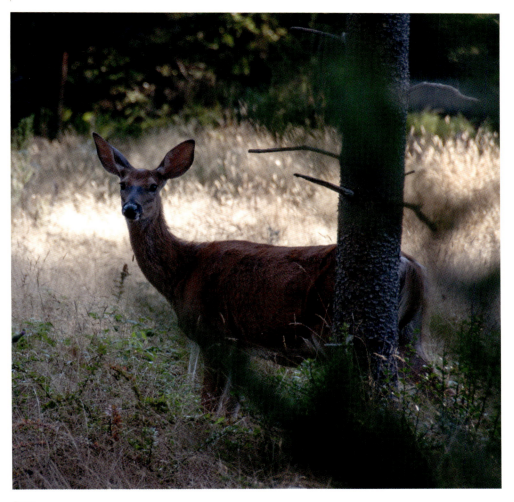

Deer

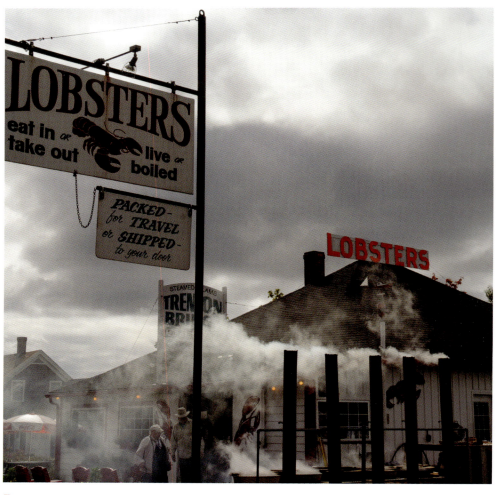

Trenton

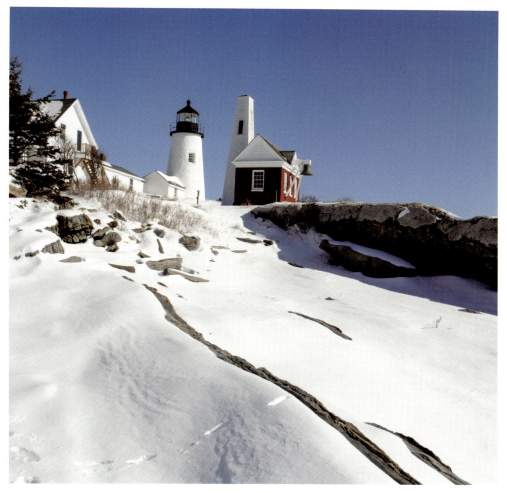

Pemaquid Point

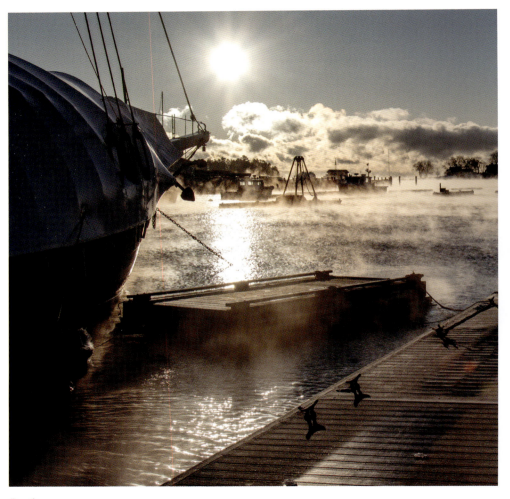

Camden

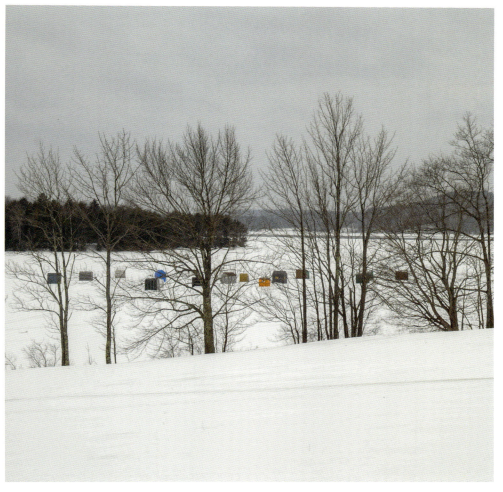

Ice fishing

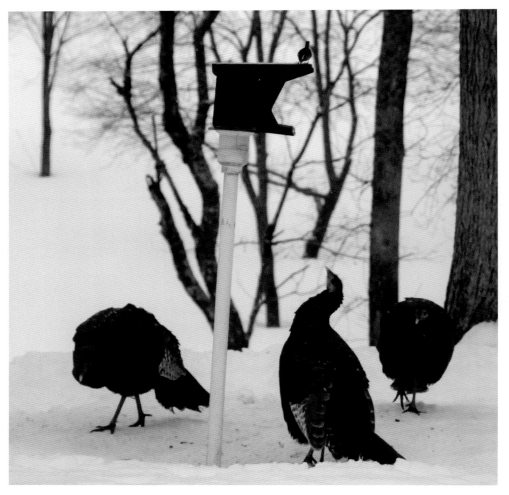

Wild turkeys, Alna

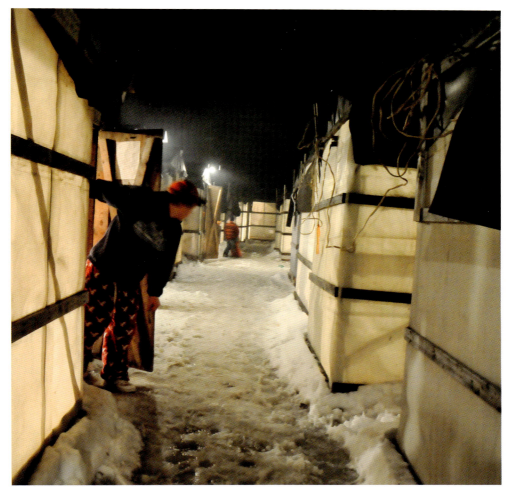
Ice fishing, Kennebec River, Randolph

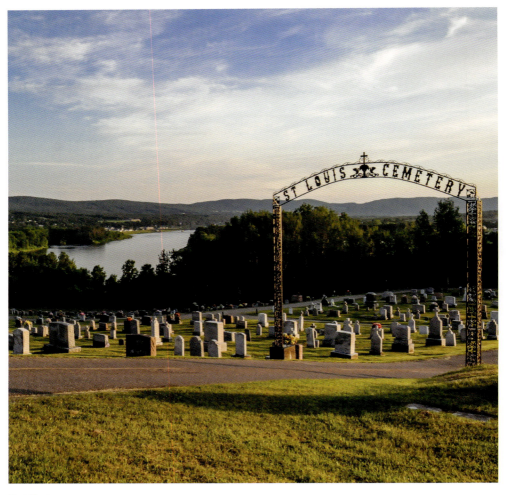

Fort Kent

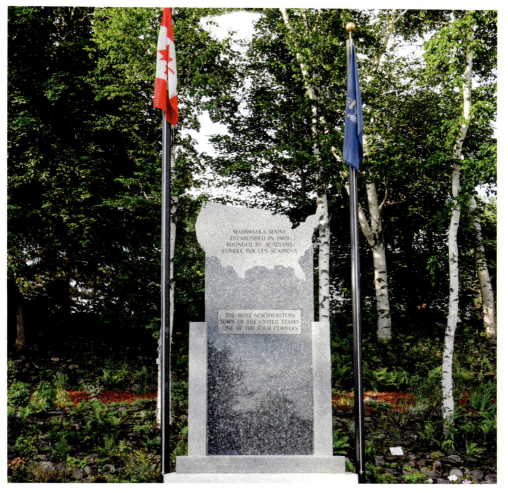

Madawaska

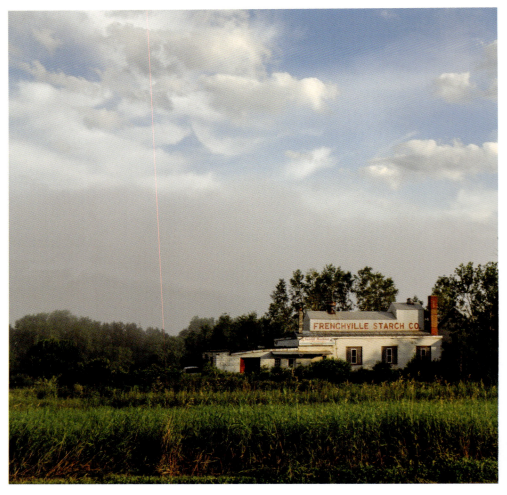

Frenchville

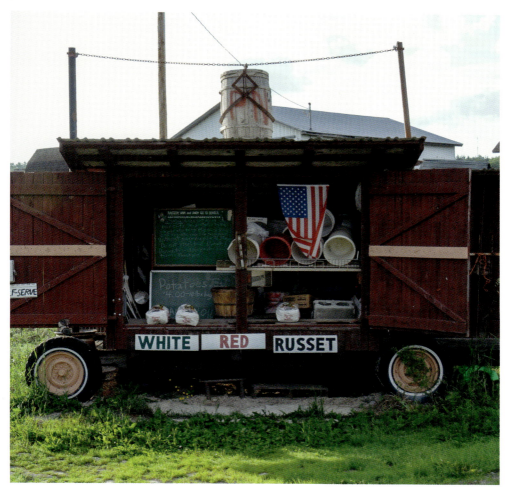

Frenchville

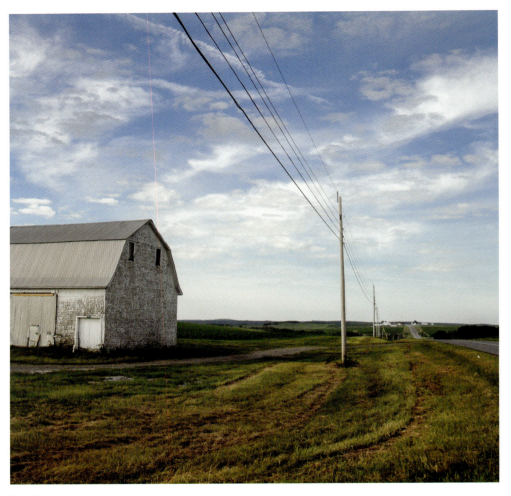

Van Buren

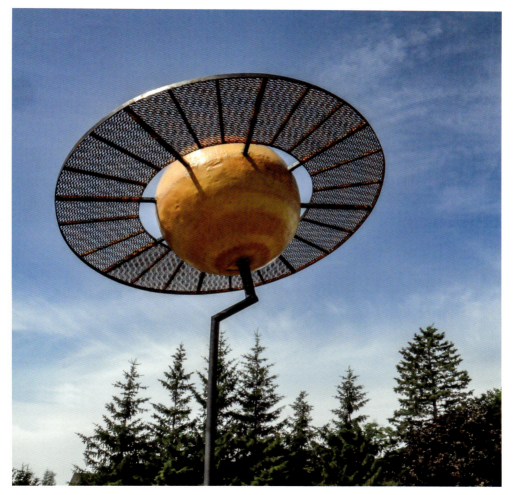

Presque Isle

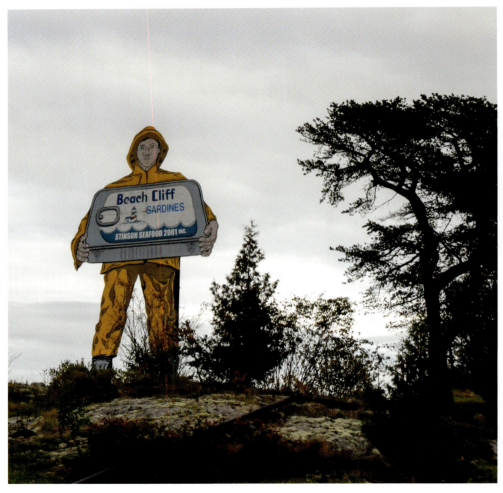

Prospect Harbor

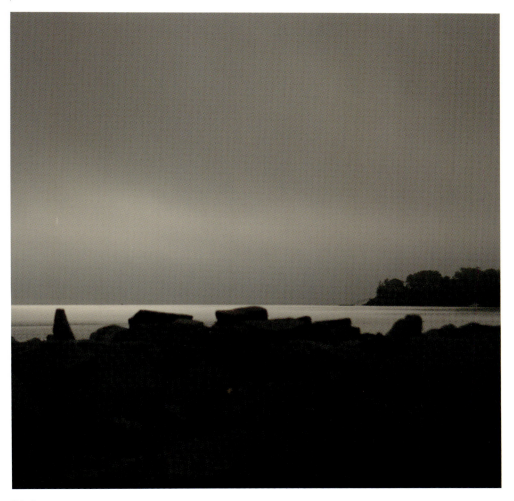

Islesboro

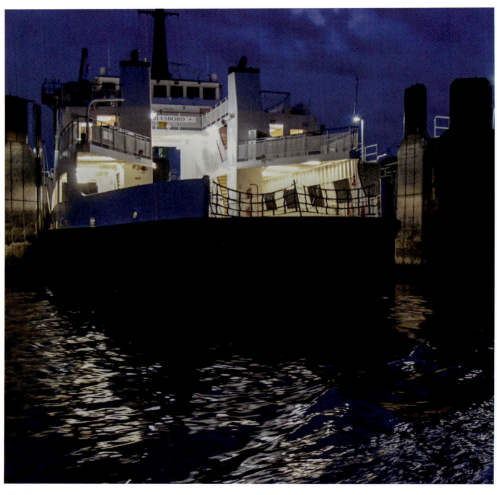

Islesboro

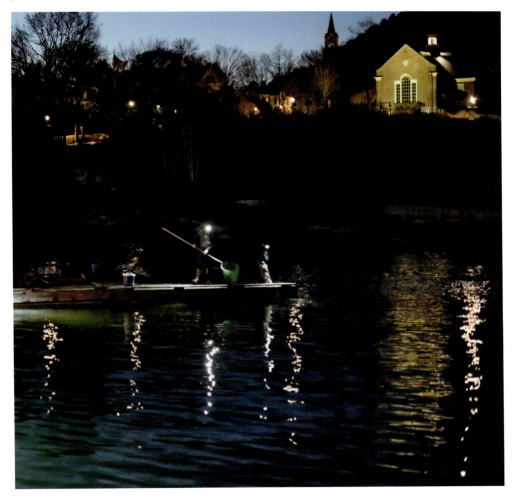

Camden

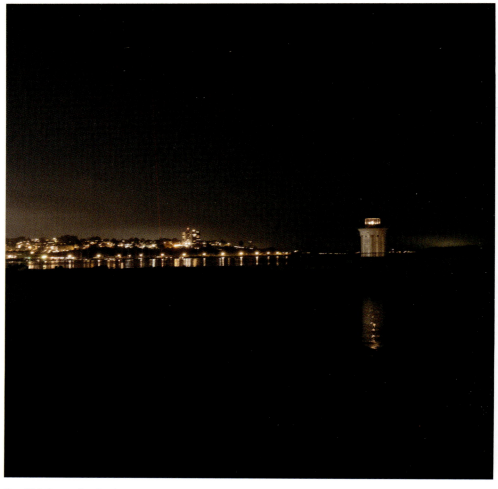

Bug Lighthouse, Portland

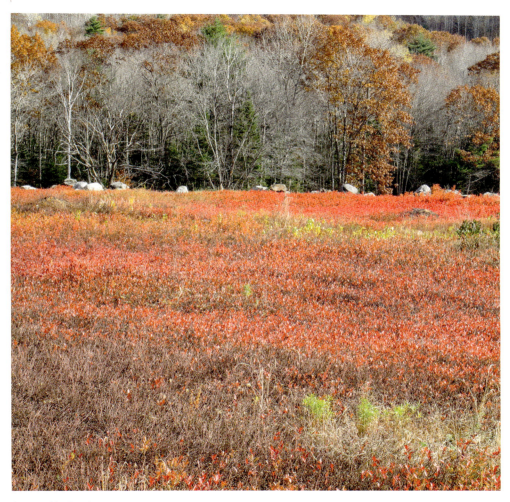

Autumn blueberries

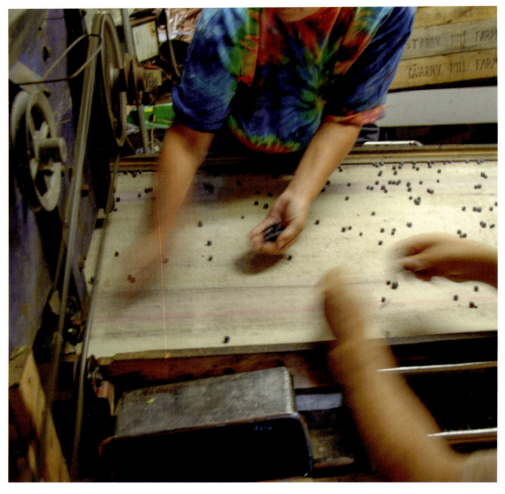

Waldoboro

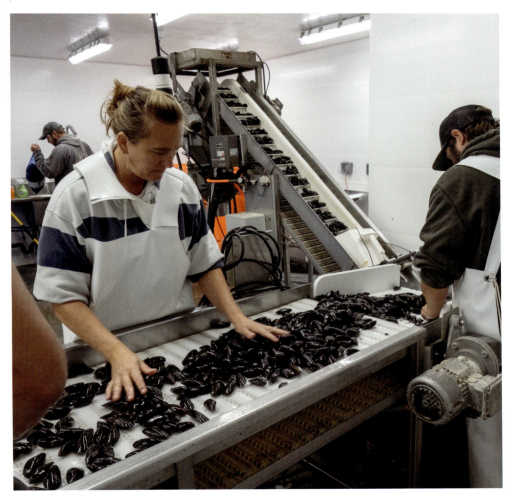

Islesboro

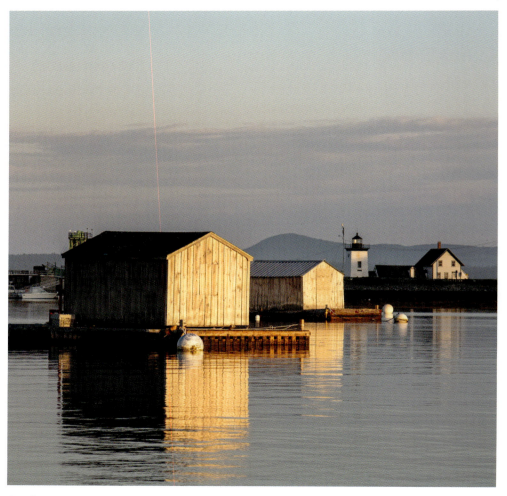
Grindle Point, Islesboro

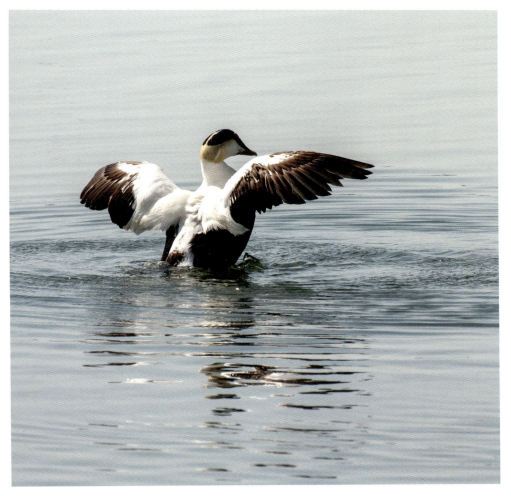

Eider duck

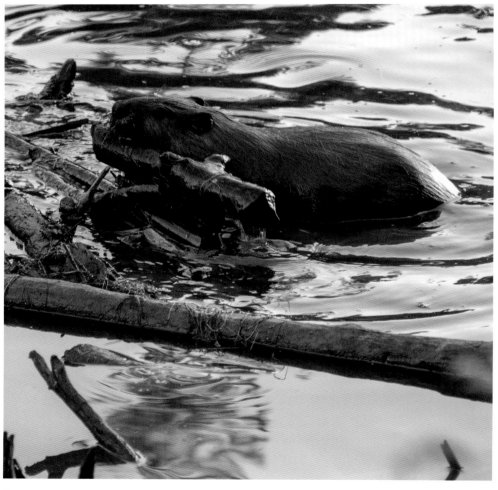

Beaver

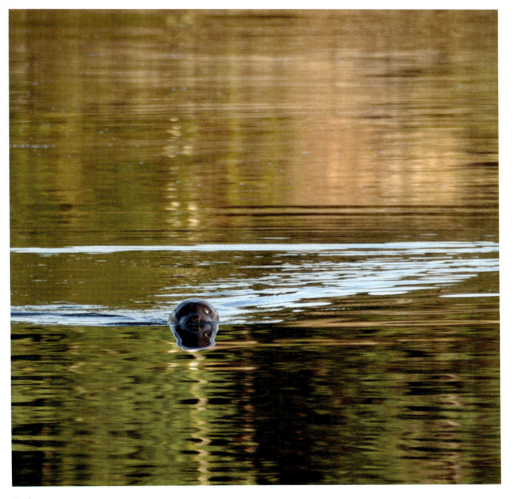

Seal

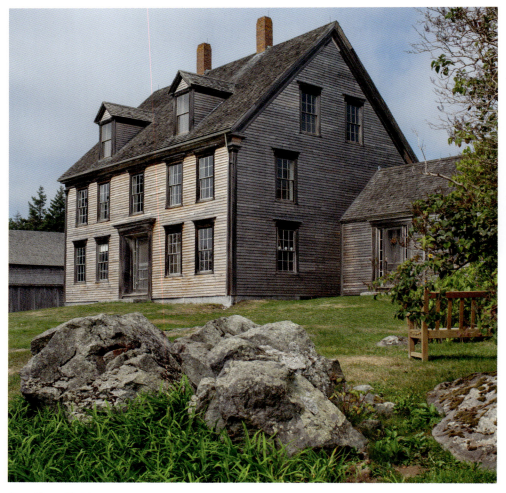

Olson House, Cushing

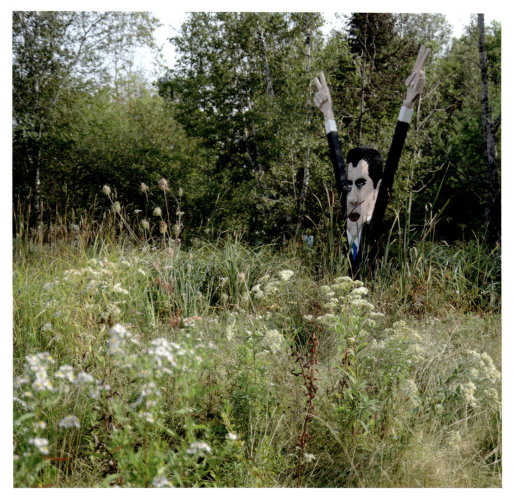

Langlais Sculpture Preserve, Cushing

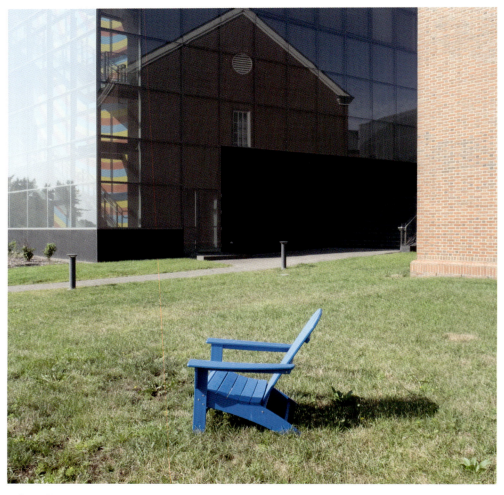

Colby College Museum of Art, Waterville

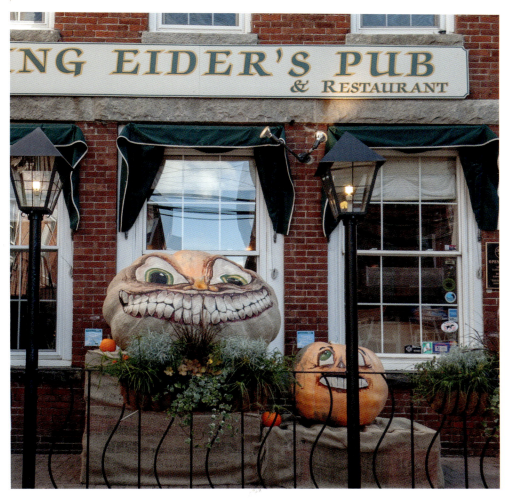

Damariscotta

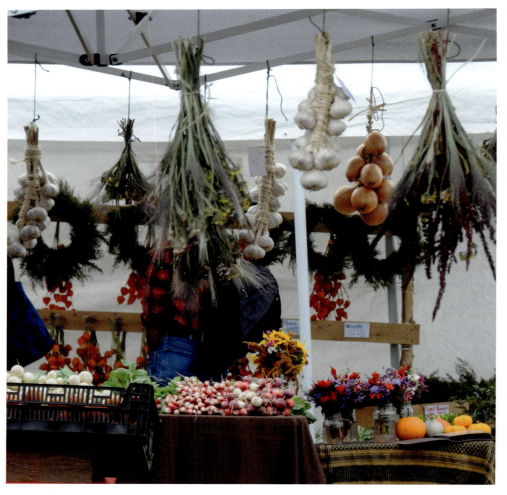

Common Ground Fair, Unity

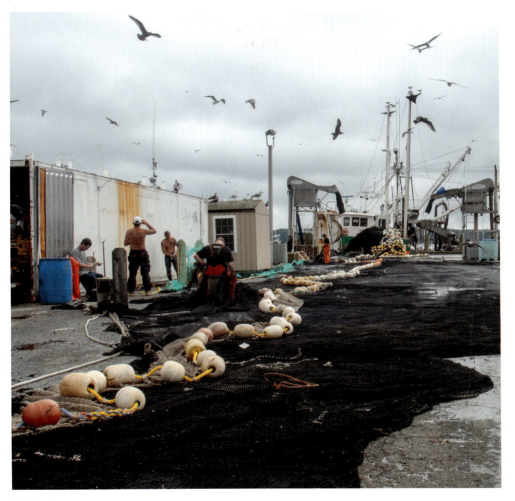

Rockland

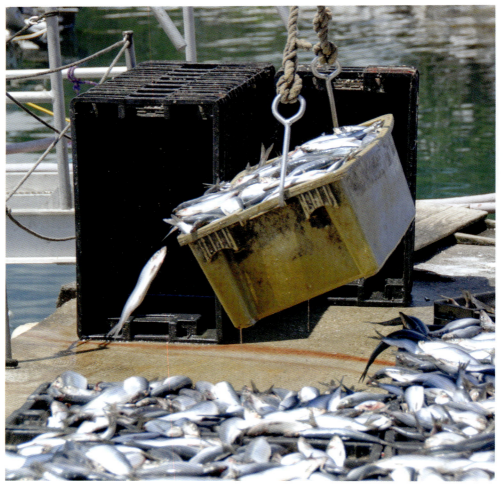

Portland

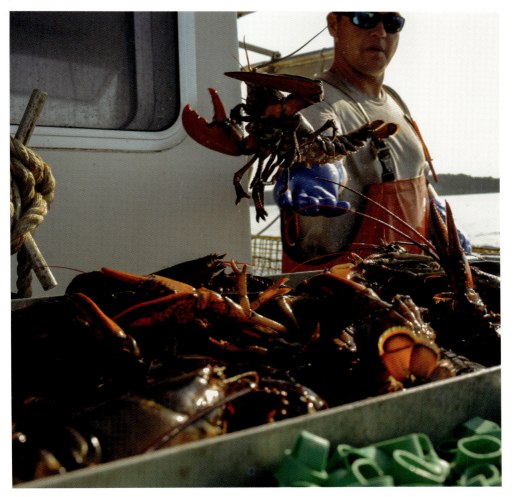
Lobster fishing

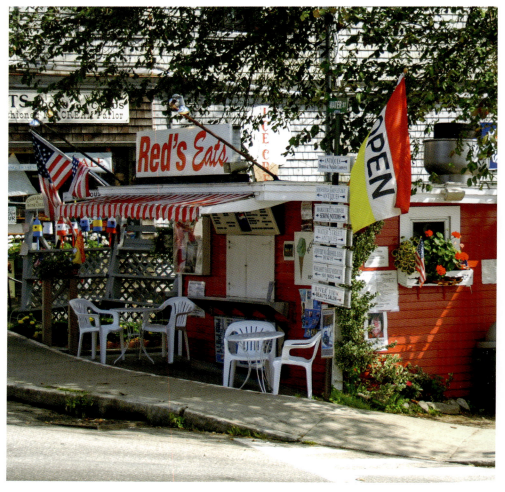

Wiscasset

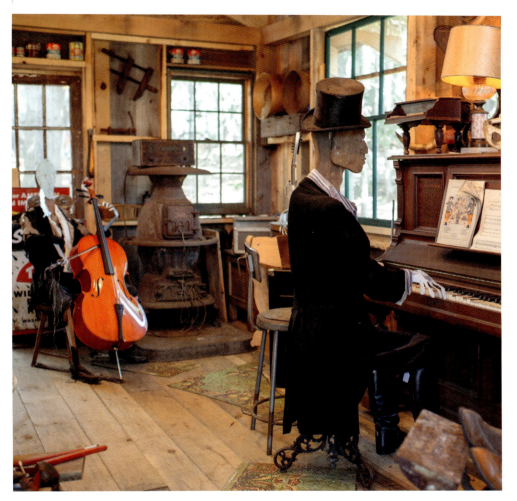

Nervous Nellie's Jams & Jellies, Deer Isle

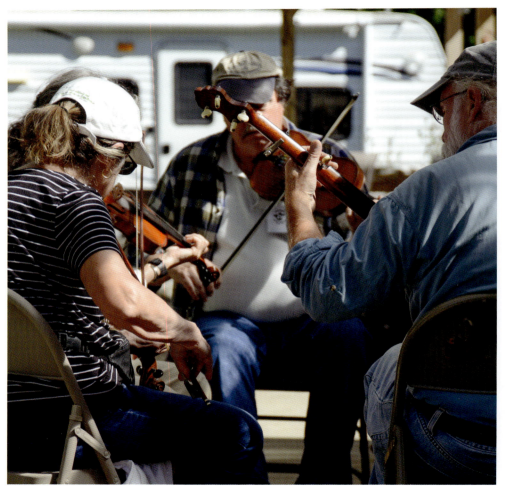

Old-time music jam

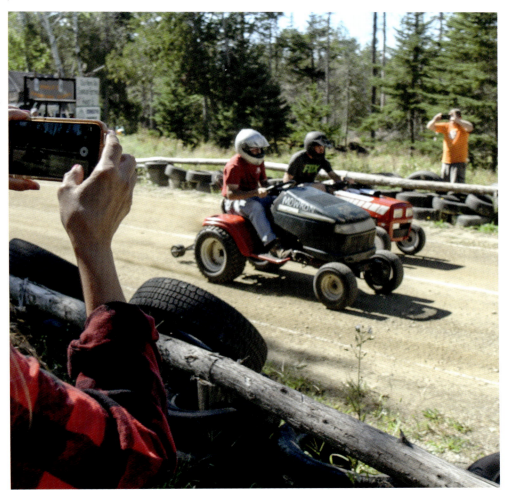

Lawn mower racing

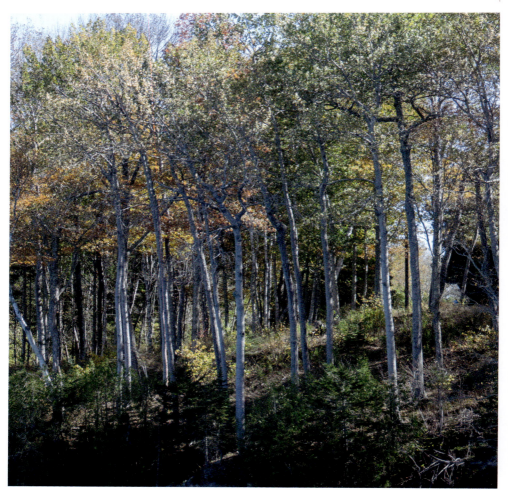

Birch trees

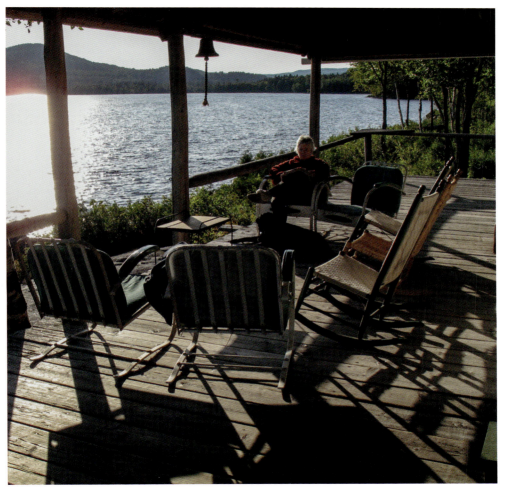

Jackman

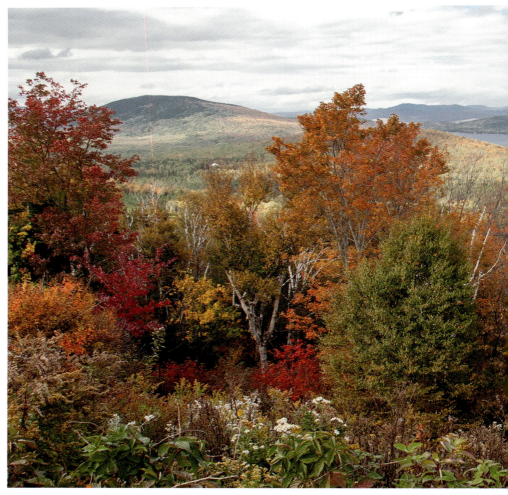

Rangeley

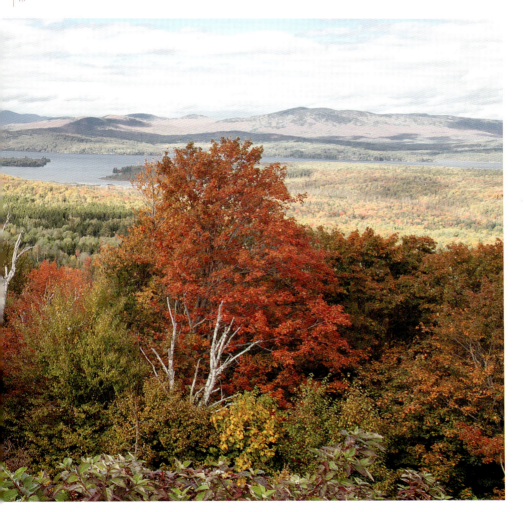

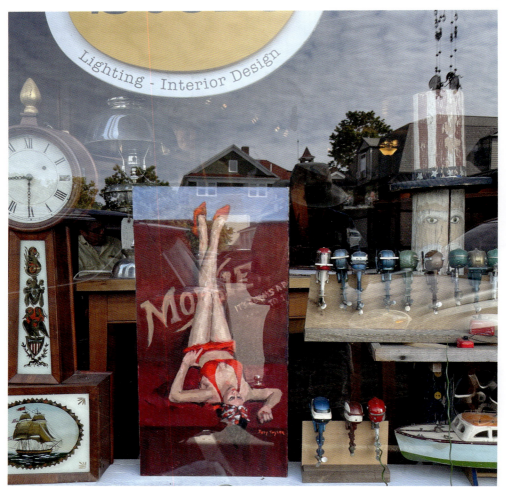

Southwest Harbor

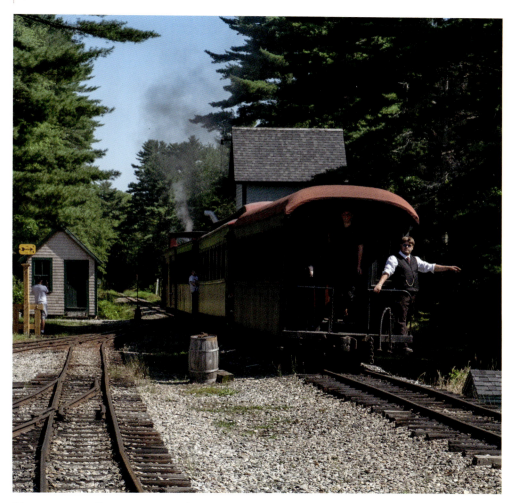
Wiscasset, Waterville & Farmington Railway, Alna

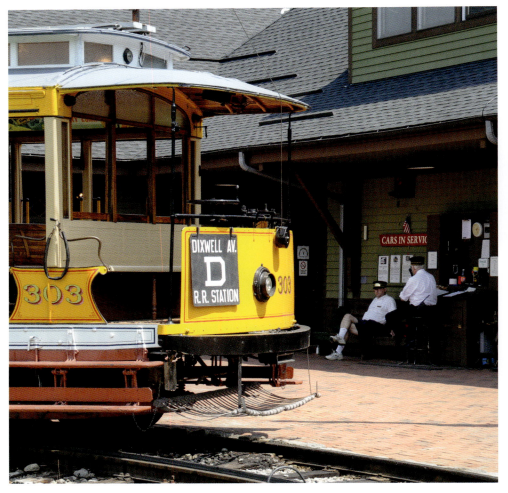

Seashore Trolley Museum, Kennebunkport

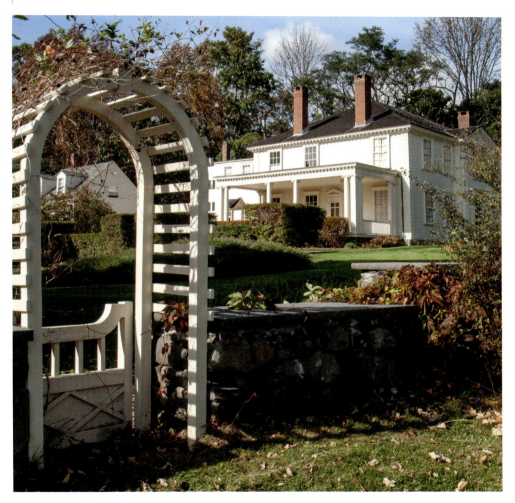

Lady Pepperrell House, Kittery

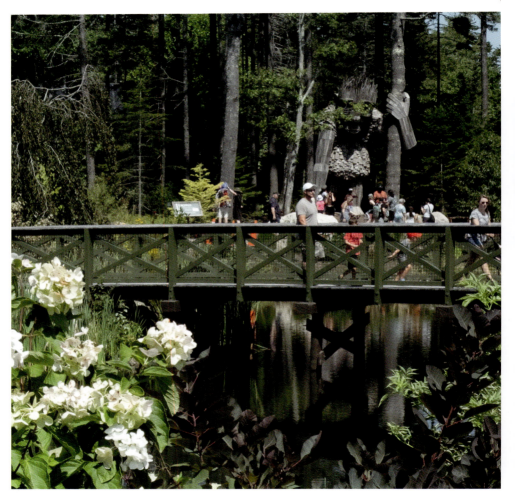

Coastal Maine Botanical Gardens, Boothbay

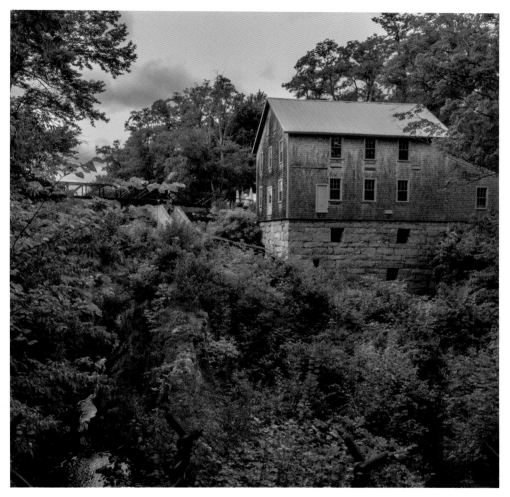

The Lost Kitchen, Freedom

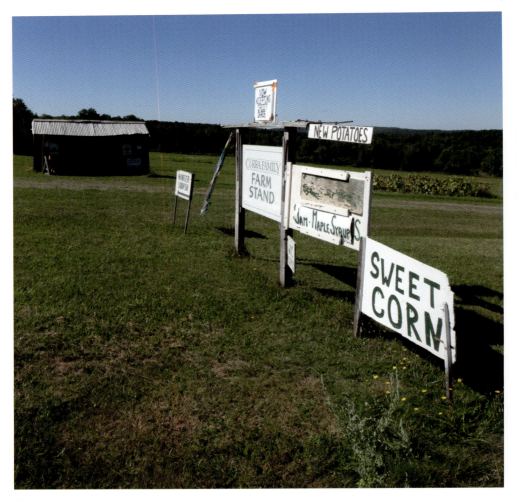

Freedom

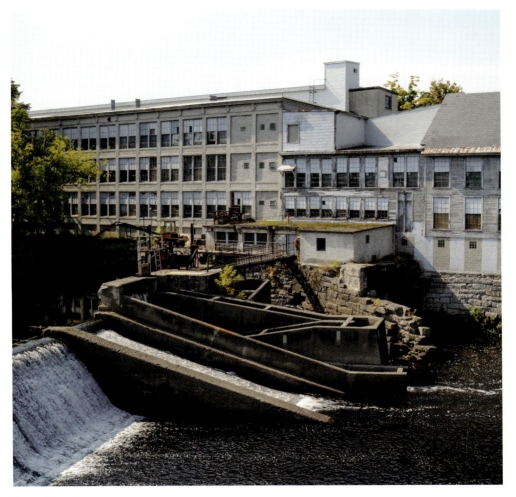

Dover-Foxcroft

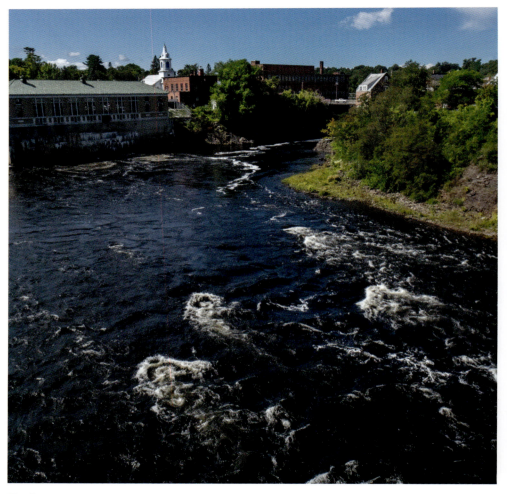

Skowhegan

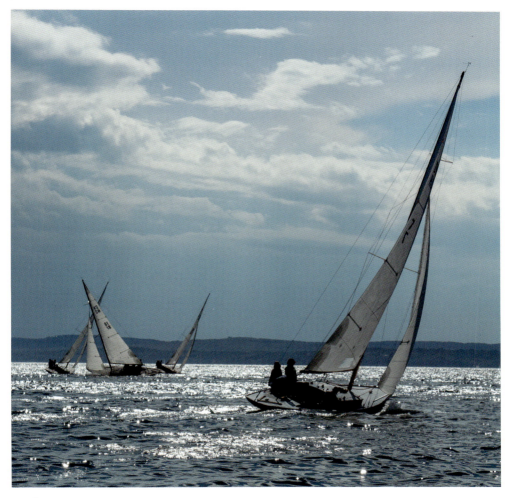

Penobscot Bay

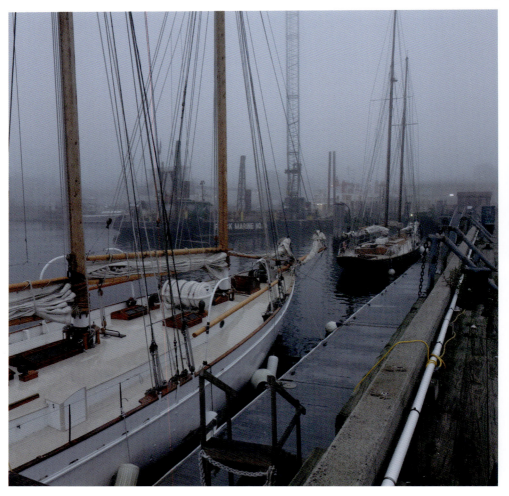

Portland

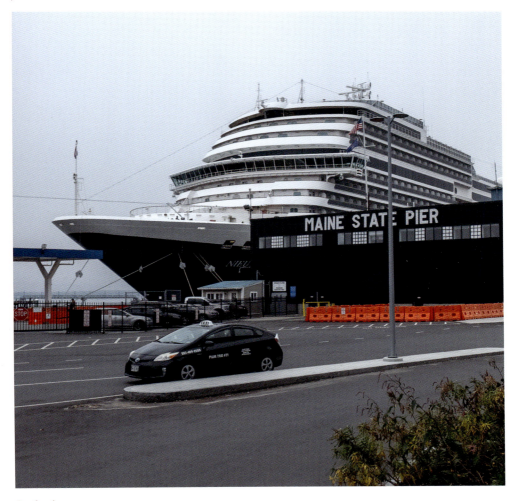

Portland

DeLorme/Garmin, Yarmouth

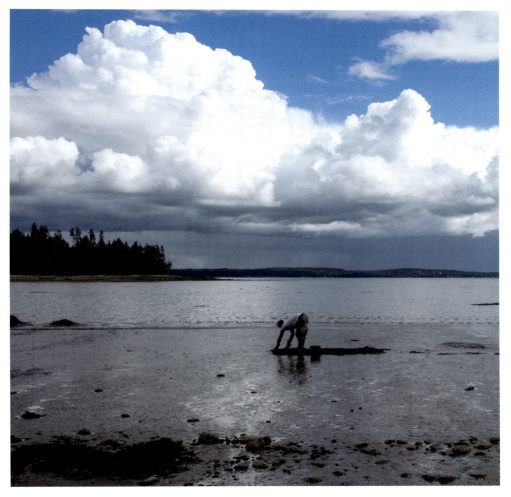

Bloodworm digging

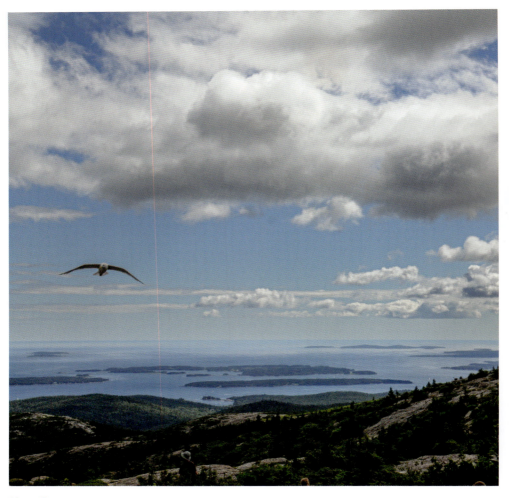

Mount Desert

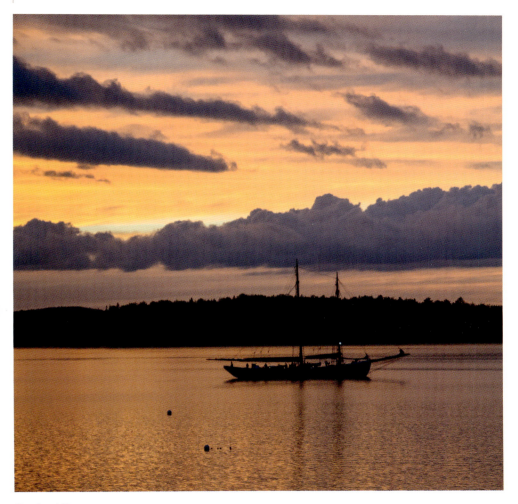
Penobscot Bay

Antelo Devereux Jr. has been photographing for the better part of his life, first as an amateur and more recently as a professional. He has published eleven travel-oriented books and has exhibited his images in various venues and galleries in Maine, Vermont, Pennsylvania, and Delaware. He has degrees from Harvard University and the University of Pennsylvania and has studied at Maine Media Workshops. He lives with his family in Chester County, Pennsylvania, and spends summers in Maine. His photographs can be seen on Instagram @photoeye1.

OTHER **SCHIFFER** **BOOKS** BY THE AUTHOR:

Coastal Maine: A Keepsake, 978-0-7643-5575-2

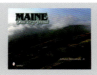

Maine: Out & About, 978-0-7643-3492-4

OTHER **SCHIFFER** **BOOKS** ON RELATED SUBJECTS:

Embracing Light: A Year in Acadia National Park & Mount Desert Island, Scott Erskine, 978-0-7643-5750-3

Sketchbook Traveler: New England, James Lancel McElhinney, 978-0-7643-6616-1

Copyright © 2024 by Antelo Devereux Jr.
Library of Congress Control Number: 2023941111

All rights reserved. No part of this work may be reproduced or used in any form or by any means—graphic, electronic, or mechanical, including photocopying or information storage and retrieval systems—without written permission from the publisher.

The scanning, uploading, and distribution of this book or any part thereof via the Internet or any other means without the permission of the publisher is illegal and punishable by law. Please purchase only authorized editions and do not participate in or encourage the electronic piracy of copyrighted materials.

"Schiffer," "Schiffer Publishing, Ltd.," and the pen and inkwell logo are registered trademarks of Schiffer Publishing, Ltd.

Designed by Danielle D. Farmer
Cover design by Jack Chappell
Type set in Bell MT/Bodoni URW

ISBN: 978-0-7643-6742-7
Printed in China

Published by Schiffer Publishing, Ltd.
4880 Lower Valley Road
Atglen, PA 19310
Phone: (610) 593-1777; Fax: (610) 593-2002
Email: info@schifferbooks.com
Web: www.schifferbooks.com

For our complete selection of fine books on this and related subjects, please visit our website at www.schifferbooks.com. You may also write for a free catalog.

Schiffer Publishing's titles are available at special discounts for bulk purchases for sales promotions or premiums. Special editions, including personalized covers, corporate imprints, and excerpts, can be created in large quantities for special needs. For more information, contact the publisher.